ANDY WARHOL
WORK AND PLAY

ANDY WARHOL
WORK AND PLAY

Published by the Robert Hull Fleming Museum
Burlington, Vermont

This book is published on the occasion of the exhibition *Andy Warhol Work and Play* at the Robert Hull Fleming Museum, University of Vermont, Burlington, Vermont January 26 – June 8, 2003

© 2003 Robert Hull Fleming Museum

Design: Tina Christensen, Christensen Design

Front and Back Covers: Gerard Malanga. *Andy Warhol Photomaton Portraits*, ca, 1964 (detail)16 x 20", Collection and © Gerard Malanga

ISBN 0-934658-10-2

INSTITUTE *of* MUSEUM *and* LIBRARY SERVICES

CONTENTS

FOREWORD

Janie Cohen, Director
Robert Hull Fleming Museum

This catalogue was published by the Robert Hull Fleming Museum at the University of Vermont on the occasion of the exhibition *Andy Warhol Work and Play*. The exhibition was the result of a variety of factors, some serendipitous: a generous offer by a University of Vermont alumnus to exhibit a significant part of his collection; a chance phone call to the Museum from Warhol-collaborator Gerard Malanga, trying to track down an old friend; the helpful assistance of the Warhol Foundation for the Visual Arts; an unexpected display of early Warhol drawings, in a local used bookstore, given to the proprietor by a classmate of Warhol's who had lived in Vermont; and generous colleagues at museums both large and small.

Outside of America's urban centers, museum audiences rarely have the opportunity to see work by Warhol beyond the artist's pop icons. A goal of this exhibition is to bring together a body of work that reflects the great variety in Warhol's artistic production during the course of his life, from early blotted-line drawings to late abstract and religious paintings. Through a rich range of canvases, prints, drawings, photographs, and rarely seen ephemera, the Fleming Museum hopes to convey the breadth of Warhol's artistic activities and his transformative role in the creative expression of his times.

We have chosen to narrow our focus in this publication to an aspect of the artist's public persona that has received relatively little scholarly attention: Warhol's interviews. In her thoughtful essay on this subject, art historian Reva Wolf examines some of the formal characteristics of what might arguably be considered another form of Warhol's art. Alongside her essay, we have reprinted two interviews with the artist selected by Wolf. The first appeared in the December 1962 issue of *Art Voices*, introduced by a very amusing *mise-en-scène*; the second, an interview by Matthew Collings, was originally published in the September-October 1986 issue of the British art journal *Artscribe*. A selection of works from the exhibition are reproduced throughout the essay and the checklist that documents *Andy Warhol Work and Play*.

Funding for the exhibition has been generously provided by the Walter Cerf Exhibitions Endowment Fund; S. T. Griswold & Company, Inc; and the Institute of Museum and Library Services, a Federal agency that fosters innovation, leadership and a lifetime of learning. We extend our deep appreciation to Jager Di Paola Kemp Design for their significant contribution of professional services and support for the

exhibition project and website, to Christensen Design for their contribution of design services for this exhibition catalogue, and to Stephen D. Kelly for catalogue support.

We are most grateful to the following individuals and lending institutions that helped to realize this exhibition: Martina Batan, Ronald Feldman Fine Arts; Mark Ciufo, North Country Books; Vincent Fremont and Claudia Defendi, Warhol Foundation for the Visual Arts; Barbara Hitchcock, The Polaroid Collections; David Kiehl, Whitney Museum of American Art; Christopher Makos; Gerard Malanga; Nicholas Sands, Sands & Company Inc. Fine Art; Richard Saunders, Middlebury College Museum of Art; and Linda Shearer, Williams College Museum of Art. The lead lender to the exhibition has chosen to remain anonymous; we are extremely grateful to him for sharing his collection with his *alma mater* and with the Burlington community. As Director, I would also like to thank the intrepid and consummately professional staff of the Fleming Museum, in particular Darcy Coates, registrar; Merlin Acomb, exhibition designer and preparator; and Jennifer Karson, public relations coordinator. Thanks also to those individuals who have worked closely with the Museum on the myriad aspects of exhibition and program planning, in particular, Jessica Dyer, Jim Gleason of Transport Consultants International Inc., Ken Mills, and Mara Williams. The contributions of everyone involved are sincerely appreciated.

INTERVIEW

Art Voices
December 1962

Pop Art? Is It Art?
A Revealing Interview with Andy Warhol*

Love is not sweeping the nation, Pop Art is. Not only America but this new craze of the avant-garde is sweeping France, England, Italy, Sweden — at least those are the countries represented in the wild exhibition of "Factual Paintings and Sculpture", at the Sidney Janis gallery, ending December 1. The New York Times headlined the art free-for-all: "Avant-Garde Revolt." Mr. Janis dignified this new movement with the tag, "New Realists", and said this is not Dada, it is "the healthy cry of a new generation." The Times stated that Pop Art mocks U.S. culture. "It's mad, mad, wonderfully mad. It's also (at different times) glad, bad and sad, and it may be a fad," the Times critic wrote, proclaiming that Pop Art is "officially" here, "an artful attempt to enrich spiritual poverty." There's a lot of sign-painting technique in Pop Art. Pop artists dote on advertisements, comic books, do-it-yourself cut-outs. Dada wanted to destroy art whereas Pop art does not take itself seriously: it whoops with deadpan laughter, irreverently deriding today's plastic culture and conformity. Our U.S. artists seem defter in poking fun at America and much better at this whoop-de-doo than those poky Europeans.

Andy Warhol had several paintings in the Janis exhibition, along with his wise-cracking peers Agostini, Arman, Dine, Indiana, Klein, Lichtenstein, Moscowitz, Oldenburg, Rosenquist, Thiebaud, Tinguely, among others. Warhol is an erstwhile commercial artist. He is a serious painter who creates forbidding Campbell soup cans, Coca Cola bottles (Pepsi too), movie stars, matchbox covers, a New York Mirror front page. We visited Warhol in his studio and found the young man to be a true original — fey, wry, impossible to engage in serious conversation. He is a lark. We said let us interview you as spokesman for Pop Art, and he said no, let me interview you. We said no, let us interview you. Well, he said, only if I may answer your questions with Yes and No. We sat on a sofa, surrounded by new canvases of Marilyn Monroe and Troy Donahue (the latter is Warhol's favorite movie star only he has never seen him on the silver screen). Movie, baseball and physical culture magazines were strewn about. Bookshelves, barren of books, held cans of beer, fruit juice, cola bottles. Jukebox pop tunes played incessantly so we yelled our first question above "Many a tear has to *fall*, but it's *all* in the game."

*reprinted verbatim

Question: What is Pop Art?
Answer: Yes

Question: Good way to interview, isn't it?
Answer: Yes.

Question: Is Pop Art a satiric comment on American life?
Answer: No.

Question: Are Marilyn and Troy significant to you?
Answer: Yes.

Question: Why? Are they your favorite movie stars?
Answer: Yes.

Question: Do you feel you pump life into into dead clichés?
Answer: No.

Question: Does Pop Art have anything to do with Surrealism?
Answer: Not for me.

Question: That's more than one word. Sick of our one-word game?
Answer: Yes.

Question: Do billboards influence you?
Answer: I think they're beautiful.

Question: Do Pop Artists defy abstract expressionism?
Answer: No, I love it.

Question: Do Pop Artists influence each other?
Answer: It's too early to say anything on that.

Question: This is not a Kennedy press conference. Is Pop Art a school?
Answer: I don't know if there is a school yet.

Question: How close is Pop Art to 'Happenings'?
Answer: I don't know.

Question: What is Pop Art trying to say?
Answer: I don't know.

Question: What do your rows of Campbell soup cans signify?
Answer: They're things I had when I was a child.

Question: What does Coca Cola mean to you?
Answer: Pop.

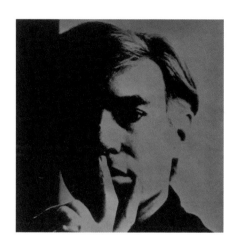

WORK INTO PLAY:
ANDY WARHOL'S INTERVIEWS

Reva Wolf, Associate Professor
Art History Department
State University of New York, New Paltz

What is Pop Art trying to say?

I don't know.

(1962)[1]

How did you get started making movies?

Uh.....I don't know.

(1966)[2]

What do you believe in?

Andy Warhol put his fingers in front of his mouth in a characteristic gesture. It was as though he wanted to stuff the words back in as they came out. "I don't know," he said. "Every day's a new day."

(1966)[3]

What is your role, your function, in directing a Warhol film?

I don't know. I'm trying to figure it out.

(1970)[4]

But why Elvis Presley, I mean why did you suddenly pick on poor Elvis to do the silkscreens of?

I'm trying to think. I don't know.

(1972)[5]

What does life mean to you?

I don't know. I wish I knew.

(1975)[6]

With answers like these, it's no wonder that Andy Warhol was described, from early on in his fine art career, as evasive in his responses to interview questions. Reporters characterized him, for example, as "impossible to engage in serious conversation," "evasive about his background," and "a listless conversationalist, totally passive."[7] Yet with his lack of seriousness in interviews, Warhol produced some remarkable consequences. He provokes us to think about the nature of interviews themselves: their history, how they are made, their role in artistic reception, their potential to enter-

tain us and even to be an art form. Warhol's transformation of the interview with the artist — generally speaking, one of the more prosaic forms of journalism — into a creative act, is no small feat. A few writers already have recognized the art in Warhol's interviews.[8] What I want to do here is to delve into how this art came about, focusing on three of the most conspicuous devices Warhol used to turn the work of the interview into play, and the play of it into art: 1) the seemingly banal answer; 2) role reversal or role confusion; and 3) appropriated ideas, formats, and language.

When the question put to him was designed to elicit a serious, art-historical, and inherently self-important response, Warhol inevitably responded with answers that on the surface seemed utterly frivolous and beside the point. These responses reflect a "pop" sensibility, and are verbal equivalents to the subject matter of some of his best-known paintings, such as the Campbell's Soup cans. They tend to have a comic effect, and in their humor they show us the absurd and cliché components of some standard questions found in interviews with artists.

Asking artists their opinions about their predecessors is one of these standard questions. In fact, a veritable genre of interviewing prevalent during the 1970s and 1980s consisted of a journalist asking a range of artists their thoughts about a particular art-world luminary. For instance, Judd Tully polled Warhol and eleven other artists about Picasso's significance on the occasion of a 1980 Picasso retrospective at the Museum of Modern Art in New York. The artists' replies were largely predictable and repeated what were by then commonly held views. Paul Jenkins tells us that, "to me, the dominant feature of his work is the distortion of the classical which eventually became the classical itself." Romare Bearden explains that Picasso "remained a very Spanish painter." Roy Lichtenstein says, "I think of Picasso as the most important artist of the twentieth century."[9] Warhol, avoiding such pronouncements, offers this observation:

> Ah, the only thing I can really relate to is his daughter Paloma. She's wonderful. Do you know her at all? She comes to town. You should maybe interview her sometime. She comes here every other week. I'm just glad he had a wonderful daughter like Paloma.[10]

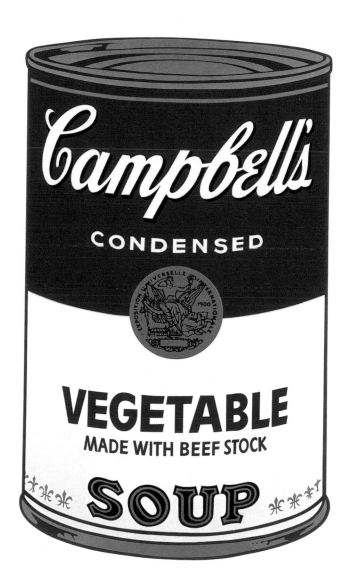

Warhol in fact did often socialize with Paloma Picasso in the late 1970s and early 1980s (and *he* had actually worked on an interview with her).[11] It is also true, however, that from the outset of his painting career he had made careful study of Picasso's art, prolific output, and stature.[12] His choice to talk about Paloma when the topic at hand was really her father trivializes the entire discussion of Pablo Picasso's artistic merit. Yet Warhol uses his banal response here, as elsewhere, to avert the risk of sounding pompous. As if by some slight of hand, his reply sounds fresh and original, while, by comparison, those of his colleagues end up sounding trite and cliché.

Nearly ten years earlier, Warhol had delivered a similar response when the critic Jeanne Siegel interviewed him along with several other artists about the abstract expressionist painter and sculptor Barnett Newman. Like the Picasso interview compendium, this one was prompted by a major exhibition of the artist's work at the Museum of Modern Art. Each artist duly spoke about the significance of Newman's art. In this instance, even Warhol talked about the art, but only in equal measure to his discussion of Newman's social life, about which he said,

> The only way I knew Barney was I think Barney went to more parties than I did. I just don't know how he got around — I mean he'd go off to the next party. And it's just so unbelievable; why I just think he's at another party. Don't you think he's just at another party? Maybe he didn't have to work a lot if he just painted one line, so he had time for parties.[13]

Here, Warhol makes light of Newman's reductive, abstract compositions of vertical lines (although he also praises Newman's *Broken Obelisk* sculpture [1963-67] in this same interview). But any conversation about art is covered over by what appears to be some banal chitchat about parties. Still, under this cloak of banality, he loosely conceals a surprising poignancy, which is exposed once we realize that Newman had died in 1970, just a year prior to this interview. At this point, it becomes clear that being "at another party" is Warhol's idea of Newman's afterlife, and that there is a real pathos in his words.

The apparent banality of Warhol's comments tended to intensify when he disliked or felt uncomfortable with the interviewer. When, in a 1971 documentary film,

art critic Barbara Rose asked him what he thought of the artist Jasper Johns (whose work is often noted as a strong early influence on Warhol), he responded with a simple and characteristic "I think he's great." When pressed to say why, Warhol explained, "Ohhh, uh, he makes such great lunches. He does this great thing with chicken. He puts parsley *inside* the chicken."[14] While it very well may have been true that Johns was a terrific cook, Warhol's description of his chicken recipe was, needless to say, not the kind of information Rose was seeking, and was clearly meant to rile her.[15] At the same time, it is likely Warhol here found a way to "out" Johns by focusing on a stereotypically female activity. (Johns, as Warhol was aware, preferred to keep his sexual preferences private and lacked the "swish" mannerisms that Warhol himself enjoyed playing up.)[16] And so his banality now becomes a form of exposure, while also being a means of avoiding the commonplace pronouncements about artistic influence that are the bread-and-butter of art history and of interviews with artists.

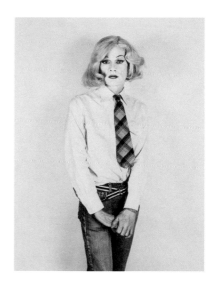

As I've already suggested, Warhol's seemingly banal responses are, in more general terms, a way to spice up interview conversations, which have a tendency to be rather bland. It is quite difficult to give an inventive, let alone interesting, answer to the stock question, "What is the significance to you of John Doe's work?" Yet, the inventive answer is what artists may well feel pressured to deliver, since creativity is, after all, what they are to represent. Warhol managed to achieve this inventiveness, despite (and very possibly on account of) the limitations of the interviewing process.

Warhol achieved this inventiveness with his seemingly banal answers, but also through reversing and otherwise confusing the roles of interviewer and interviewee, the second form of his verbal evasiveness that I want to consider here. He attempted to use this approach already in one of the very first recorded interviews with him, of 1962, published in the magazine *Art Voices* (and reprinted in the present catalogue). By way of introducing the interview, the magazine's editors inform us that they told Warhol, "let us interview you as a spokesman for Pop Art, and he said no, let me interview you."[17]

By the mid 1960s, stories circulated of how Warhol would ask interviewers to provide the answers to their own questions. In the 1965 book *Pop Art*, we learn that when a reporter questioned Warhol about his background, he proposed, in response,

"Why don't you make it up?"[18] The following year, art critic Alan Solomon recounted his experience of trying to interview Warhol for television. "I'll tell you what," the artist proposed, "why don't you give the answers too." Solomon objected on the grounds that he did not know the answers. "That's alright," Warhol responded, "[j]ust tell me what to say."[19] Warhol most likely had in mind here the widespread Hollywood practice of the studio controlling what its movie stars said in interviews — the actors were told, quite literally, what to say.[20] No doubt, he would have been familiar with such scripted interviews as a boy, when he listened to the radio regularly. As an avid movie-star fan, he very probably also would have seen these interviews on the pages of magazines such as *Photoplay*.

In the interview with the artist, as in the Hollywood celebrity interview, inquiries about the interviewee's background abound, and are manifestations of a central purpose of these interviews: to reveal whatever possible about the person behind the work. It is that *person* we seek when we read or listen to an interview. And so, early in the history of published interviews with artists (at least as it unfolds in *The Art News*, a mainstay of the American art press) portraits accompanied the words, giving us a face to go with the "voice." However, in the early 1960s, when Warhol gave his first interviews, such portraits tended to be left out. This shift in publication practice reflects broader journalistic trends. Within the field of art criticism, formalist analysis, based on the belief that we should understand the art object by studying it alone, without drawing upon biographical or other kinds of information external to the art, came to exert a powerful influence in the 1950s and 1960s, as art historians have long recognized. With the same impulse to achieve objectivity, ideas concerning the role journalists play in interviews likewise changed markedly between the 1930s and the 1950s. Interviews published in *The Art News* in the 1930s were articles rather than transcriptions of dialogues, including only an occasional quotation.[21] Not until 1963 did this magazine, now recast as *ARTnews*, utilize the full-fledged question-and-answer format that is so familiar to us today. As it happens, its debut occurred in a series of interviews with several artists, called "What Is Pop Art?" and containing what remains today Warhol's most famous interview.[22] *ARTnews* most likely modeled its new interview format on popular journalism — an apt choice for a sequence of interviews about the then-still-new art that was called pop.

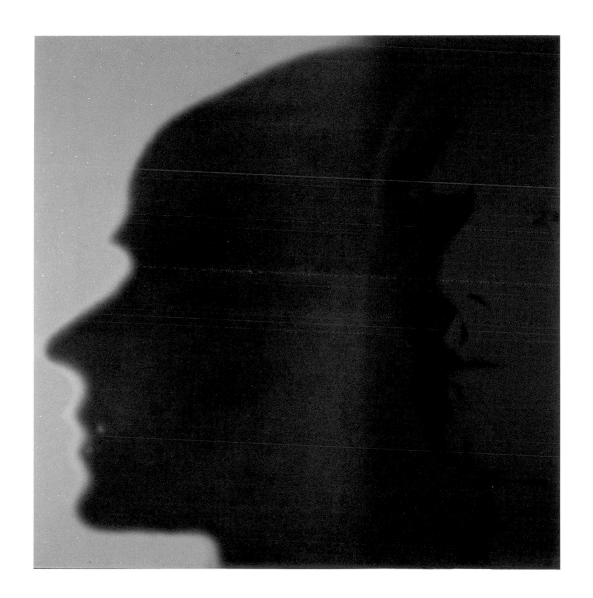

Another equally, and probably more significant, model for *ARTnews*'s new, objective-looking format, came from more highbrow journalism, most notably, *Paris Review*. This journal initiated question-and-answer format interviews as a regular feature from its inception in 1953. Soon after, the *Paris Review* interviews started to be reprinted as collections (a practice still in existence today), thereby broadening their dissemination. Malcolm Cowley observed in the introduction to the first of these collections, published in 1958, "[t]he interviewers belong to a new generation that has been called 'silent,' although a better word for it would be 'waiting' or 'listening' or 'inquiring.'"[23] The desire to repress the journalist's voice is articulated elsewhere, too, during the second half of the 1950s. For example, in the foreword to Selden Rodman's 1957 book, *Conversations with Artists*, we are told, "Rodman wisely keeps his own opinions down to a smooth purr throughout the book."[24]

It was, then, precisely when the idea of giving the interviewee more control over the content of interviews was embraced, and when the seemingly objective question-and-answer format gained wide acceptance within the realm of serious journalism, that Warhol, through his apparent evasiveness, showed that its claims to documentary objectivity were trickery. After all, interviews nearly always are rehearsed, edited and/or refined, and are not the spontaneous conversations that the question-and-answer format would imply.

Warhol's understanding of the interview was much like that of historian Daniel J. Boorstin, who, just prior to Warhol's beginnings as a sought-after interviewing subject, wrote about the interview as a "pseudo-event" in his 1961 book, *The Image*. For Boorstin, the pseudo-event is an unspontaneous occurrence that exists primarily so that it may be reported (a notion so commonly held today that we take it for granted). Boorstin argues that,

> Concerning the pseudo-event the question, "What does it mean?"
> has a new dimension. While the news interest in a train wreck is in
> *what* happened and in the real consequences, the interest in an
> interview is always, in a sense, in *whether* it really happened and in
> what might have been the motives. Did the statement really mean
> what it said?[25]

Warhol's suggestions to interviewers that they fabricate his background, or answer his questions for him, bring to the surface of the interview itself the problems Boorstin had identified as being inherent in the genre. Boorstin, however, wrote his book in order to attack as morally bankrupt the ubiquity of the pseudo-event within American culture, while Warhol took a much more complicated and also, generally speaking, more positive position toward this phenomenon. If the ambiguity of the interview in relation to reality disturbed Boorstin, it in many ways delighted Warhol. We see this delight in his recollection of what it was like to be interviewed in the mid 1960s:

> In those days practically no one tape-recorded news interviews; they took notes instead. I liked that better because when it got written up, it would always be different from what I'd actually said — and a lot more fun for me to read. Like if I'd said, "In the future everyone will be famous for fifteen minutes," it could come out, "In fifteen minutes everybody will be famous."[26]

During the early 1970s, Warhol went out of his way to heighten the confusion by videotaping or tape-recording interviews that journalists conducted with him. This activity was one form that his interviewing role reversals took. A reporter for the New York *Daily News* described how, when he visited Warhol's studio, a video recorder was taping the various "goings-on (*including* our interview)," and Emile de Antonio explained that while he made the segment on Warhol of his 1972 documentary film, *Painters Painting*, "Andy audiotaped everything."[27] By the mid 1970s, this practice reached its logical conclusion as Warhol began conducting many of the question-and-answer sessions for his *Interview* magazine, which he had established in 1969. Still later, in 1985, he moved into the arena of television interviewer with the launching of an MTV show, *Andy Warhol's Fifteen Minutes* (cut short by his death two years later).[28]

Yet even in the role of interviewer, Warhol at times continued to present himself as not knowing what to say. Bob Colacello, in his chronicle of his experiences as editor of *Interview* magazine, observed that Warhol always falsely claimed that he never knew what to ask the interviewees. According to Colacello, Warhol told him, "I'll ask a few Eugenia Sheppard questions, Bob, and then you've got to come up with

RIGHT

Gerard Malanga
Andy Warhol Photomaton Portraits, ca, 1964 (detail)
16 x 20"

Collection and © Gerard Malanga

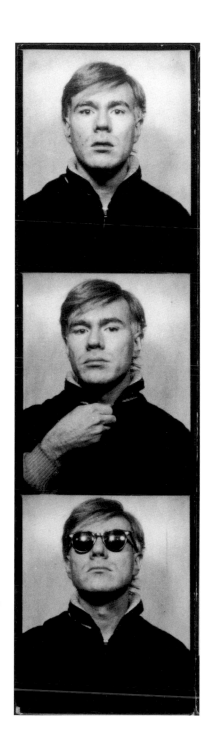

the Edward R. Murrow ones for me."[29] In other words, Warhol would play the role of fashion and gossip columnist, while Colacello would play that of serious reporter. In this statement, Warhol also reveals his awareness of and sensitivity to distinct types of journalistic interviews; this awareness gave him the potential to appropriate their formulas and language patterns.

These appropriations are the third type of apparent evasiveness I will discuss here that Warhol deployed in interviews. He helped himself freely to formulas and phrases circulating in the media, to pronouncements made by other artists, and to key words that he found in reviews of his own work, just as he pillaged the expansive visual encyclopedia of popular culture to create his paintings. In each case, we are led to an awareness of our own inevitable appropriations, whether we intend them or not, from the world of sound bytes and media imagery that swirls around us.

Warhol's most familiar interview pronouncement, "in the future, everyone will be world famous for fifteen minutes,"[30] now itself a phrase we see and hear over and over again in the press, is a good place to start as we look at his use of appropriation in interviews. His selection of the particular time interval of fifteen minutes derives, I would speculate, from the fifteen-minute duration that was standard in the field of broadcasting from the early days of radio programming to the television news shows of the 1950s and 1960s (nowadays of course these time slots are generally of thirty or sixty minutes).[31] This airtime length was even incorporated into the title of some programs, as in *Fifteen Minutes with Bing Crosby* or *The Camel Quarter Hour*, two radio variety shows of the 1930s.[32]

From his very first interviews, Warhol practiced this sort of borrowing. In his first known published interview — the one in *Art Voices* that is reprinted here — he utilized a particular standard format of interviewing, whereby the answers are either "yes" or "no." An extensive literature exists on this kind of interview, and usually interviewers are advised to avoid it because it yields only limited information.[33] Warhol used the format, in collaboration with the editors of this particular interview, to comic effect. And he used it in such a way that we actually learn more than the answers "yes" and "no" ordinarily might convey. For example, when asked, "What is Pop Art?" he replied, "Yes." This one-word utterance itself sounds "pop," but it is also a way for

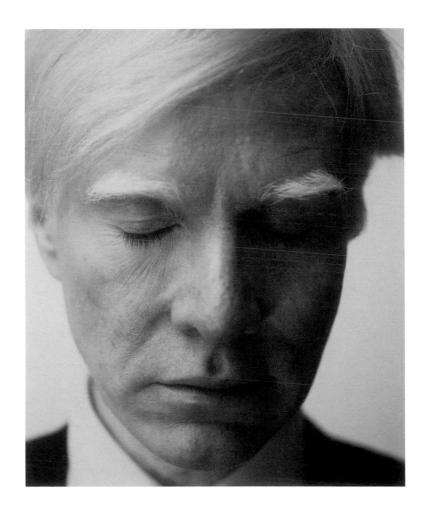

Warhol to endorse his artistic creations without coming across as pompous or heavy-handed (often a pitfall of such interviews, as I have already noted).

As the *Art Voices* interview progresses, Warhol breaks out of his self-imposed verbal straightjacket and begins to use more words, while at the same time continuing to derive his vocabulary from the wellspring of all-too-familiar, over-used expressions. Interviews with politicians (interestingly, the first modern interviews, of the mid 1850s, were, it seems, with politicians)[34] are the source for the following passage, which the questioner, as you will immediately see, rather delightfully points out.

Question: Do Pop Artists influence each other?

Answer: It's too early to say anything on that.

Question: This is not a Kennedy press conference.[35]

It is important to observe here, to digress momentarily from the topic of appropriated language, that Warhol's willingness to offer more than "yes" or "no" once he was in the midst of this interview is indicative of a pattern evident in many of his interviews. The impression is one of initial nervousness followed by a gradually more relaxed demeanor.[36] Behind this pattern was a deep fear of public speaking that went back many years. Warhol's college classmate Bennard B. Perlman recalled that when as a student the artist had to speak in front of the class, "invariably he would utter a few sentences and then freeze, unable to continue. It was a painful experience for all of us."[37] Warhol himself was perfectly frank about his at times immobilizing stagefright, describing in a 1977 interview, to take one instance, that "I was on Merv Griffin a couple of times, and I was so nervous I couldn't even get a word in."[38] The "yes" and "no" formula as well as other appropriated responses allowed him, among other things, to overcome his terror.

Once Warhol found a formula that worked in this way, he was apt to repeat it. We see the "yes" and "no" answer formula, for example, in one of the interviews included in his 1967 book *Andy Warhol's Index (Book)* (a collaborative project put together largely by his associates).[39] And we find him relying on this formula at live appearances, too. In the fall of 1967, the *New York Post* reported this story about a speaking engagement at Drew University:

The students who crowded into the Madison, N. J. campus gymnasium expected Warhol to talk on pop art and film making. Instead, Warhol showed a half-hour film and answered questions with a yes, or no.

"We paid for Andy Warhol and we didn't get two words out of him," [Thomas] McMullen [president of the student association] said.[40]

What they did get was a demonstration rather than an explanation; Warhol showed a film rather than to speak about filmmaking, and his disappointing "yes" and "no" answers were an illustration of pop art rather than a discussion of it. The event was, like so many of the published interviews, a performance (as were the cases during this time period when Warhol sent a surrogate, Allen Midgette, to lecture in his place).[41]

Warhol uttered stereotypical movie-star-like comments, one sub-category of his appropriated language, to the same effect as the "yes" and "no" responses. With these comments, he created verbal equivalences to his paintings of Marilyn Monroe, Elizabeth Taylor, and other Hollywood celebrities. In such cases, his words sound like something we might find in *Photoplay* magazine even when they were spoken to a reporter from the *New York Times*. For a 1965 *Times* article, he claimed (as he often did in the mid 1960s) that he was abandoning painting to devote himself entirely to film, and then mused, "I've had an offer from Hollywood, you know, and I'm seriously thinking of accepting it."[42] In the same vein, two years later he told an interviewer, "the only goal I have is to have a swimming pool in Hollywood."[43] Later still, in 1986, he used the term "photo opportunity," also derived from the world of celebrity — which by this date was *his* world — in such a way that he not only exposed his own appropriation of it, but also, in the process, its pretentiousness. When the interviewer, British art critic Matthew Collings, declared that Warhol's then-new book of snapshot-type photographs, *America*, was "very patriotic," Warhol replied, "[t]hat's just photo opportunity." Collings (whose interview is printed in full in this catalogue) then asked what Warhol meant by this term. Here is Warhol's explanation:

I don't know. Everybody uses that phrase. It means just being in a photo or something. When somebody says, "It's a photo

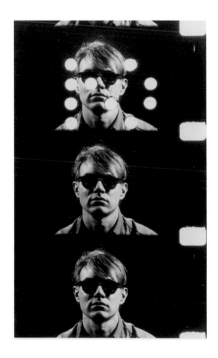

opportunity," you just stand there and they take your picture. It's actually just having your picture taken.[44]

Warhol borrowed his words from famous artists as much as from other kinds of celebrities. In the *New York Times* story in which he states that he would now devote himself to film, he calls himself a "retired artist,"[45] an idea taken from Marcel Duchamp, who had in the mid 1920s contributed to circulating a rumor that he had decided to quit making art and instead would focus his creative energies on chess-playing. Warhol also on occasion used a well-known statement from an interview with Jasper Johns, in which Johns explained that the reason he painted compositions based on the American flag and on targets was because they were "both things which are seen and not looked at, not examined...."[46] When Warhol was asked, for example, whether the subject matter of his *Last Supper paintings* (1986), based on Leonardo da Vinci's famous mural, had a particular meaning for him, Warhol responded, "It's something that you see all the time. You don't think about it."[47] Just as Duchamp and Johns had been inspirations for Warhol's visual imagery, so they were inspirations for his words. As we have seen throughout this discussion, the visual and the verbal are the weft and warp of a perfectly seamless fabric that is Warhol's art.

Perhaps the most interesting of all Warhol's verbal borrowings are the ones he took from writings about his art. When he claimed to have done something a particular way because it was "easy," he was reiterating a word used by art historian Peter Selz in an early and especially blistering assessment of pop art. In Selz's analysis, pop art lacks commitment, is cool and complacent, and, finally, is "easy." He repeats the word "easy" several times: pop art is "easy to assimilate," is "as easy to consume as it is to produce"; and, is "easy to market."[48] Rather than attempting to disprove Selz's accusation, Warhol simply used it himself. In 1965, he explained to the poet and art critic John Ashbery that while his real interest at the moment was in film, perhaps he would not give up painting after all, since "[w]hy should I give up something that's so easy?"[49] Conversely, a few years later, in an interview for *Mademoiselle* — and on numerous subsequent occasions — he claimed that he liked making films better than making paintings, because *they* were "easier."[50]

Warhol himself left behind the evidence of his practice of stealing the

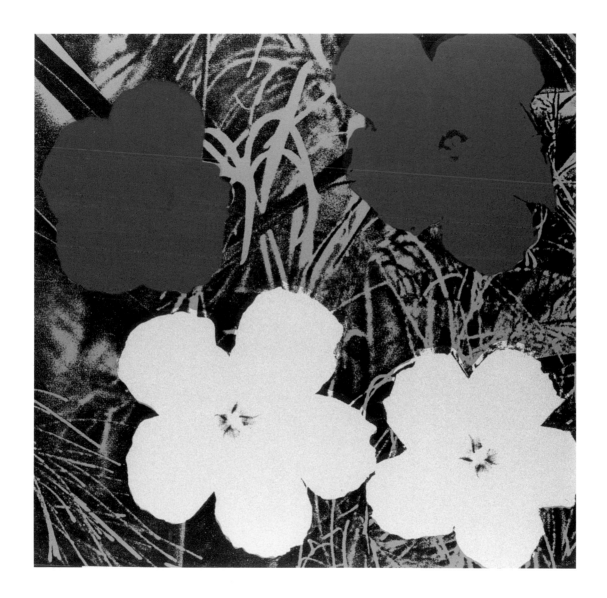

words others wrote about him. In his 1975 book, *The Philosophy of Andy Warhol*, he explained,

> I...constantly think of new ways to present the same thing to interviewers, which is [a] ...reason I now read the reviews — I go through them and see if anybody says anything to us or about us we can use.[51]

Once we understand Warhol's techniques of communicating in interviews, through the evidence he offered us and through looking at the sources of his language, we can better appreciate his mastery at interviewing, his transformation of the work of doing an interview into play, and his vision of this play as both paralleling and being a component of his art. Although other artists had given interviews that were performances (Salvador Dalí and Pablo Picasso come immediately to mind), none came even close to putting such extraordinary energy into this activity, and none had accomplished so much with it. (Only Bob Dylan can compete, and he probably learned his own interviewing tricks from Warhol.) Warhol managed to give new, and often multiple, meanings to the most prosaic and over-circulated of words. Even the phrase "I don't know," coming from him, emits to us shockwaves of meaning.

This essay is based on lectures I presented at the Institute for Advanced Study, Princeton, N. J. (February 8, 1996) and at the annual conference of the College Art Association (February 12, 1999, Los Angeles); I thank the faculty and members of the Institute for Advanced Study — most especially Irving Lavin — for their support and suggestions, and I am grateful to David Carrier and Bradford R. Collins, who chaired the College Art Association panel, for their encouragement. I also wish to thank Janie Cohen for giving me an excellent excuse to develop the two lectures into an essay. Finally, I express my gratitude to Valerie Mittenberg, a reference librarian at the State University of New York, New Paltz, for her expert help in solving a bibliographical riddle.

[1] "Pop Art? Is It Art? A Revealing Interview with Andy Warhol," *Art Voices* 1 (December 1962): 19.

[2] David Ehrenstein, "An Interview with Andy Warhol," *Film Culture* 40 (Spring 1966): 41.

[3] Leonard Shecter, "The Warhol Factory," *New York Post*, 23 February 1966.

[4] Joseph Gelmis, *The Film Director as Superstar* (Garden City, N.Y.: Doubleday, 1970), 67.

[5] David Bailey, *Andy Warhol* (television documentary transcription) (London: Bailey Litchfield/ Mathews Miller Dunbar, 1972), unpaged.

[6] Bess Winakor, "Q and A: Andy Warhol's Life, Loves, Art and Wavemaking," *Sun-Times* (Chicago), 28 September 1975.

[7] "Pop Art? Is It Art? A Revealing Interview," 18, and Gelmis, 66.

[8] See, especially, Wayne Koestenbaum, *Andy Warhol* (New York: Viking, 2001), 79-80.

[9] Judd Tully, "Artists on Picasso," *Horizon* 23 (April 1980): 50, 49, and 48, respectively.

[10] Ibid., 50.

[11] Several of his interactions with Paloma are recorded in *The Andy Warhol Diaries*, edited by Pat Hackett (New York: Warner Books, 1989); see, for example, pages 11-12, 45, 67, 133, 137, 262, 296-7 (where he discusses the interview with her), 336-7, 344, 383, 389, 414, 473, 559, and 601.

[12] See Warhol and Pat Hackett, *POPism: The Warhol '60s* (New York: Harcourt Brace Jovanovich, 1980), 72, 82, 114, and 196.

[13] Jeanne Siegel, "Around Barnett Newman," *Artnews* 70 (October 1971); reprinted in Siegel, *Artwords: Discourse on the 60s and 70s* (New York: Da Capo Press, 1992), 49.

[14] Bob Colacello described this particular interview in his book, *Holy Terror: Andy Warhol Close Up* (New York: HarperCollins, 1990), 65.

[15] Ibid., 64-5.

[16] Warhol described his sensitivity to this issue in *POPism*, 11-13. For an insightful analysis of Warhol's and Johns's sexual identities, see Ken Silver, "Modes of Disclosure: The Construction of Gay Identity and the Rise of Pop Art," in *Hand-Painted Pop: American Art in Transition*, 1955-62, ed. Russell Ferguson (Los Angeles: Museum of Contemporary Art; New York, Rizzoli, 1992), 193-97.

[17] "Pop Art? Is It Art? A Revealing Interview," 18.

[18] John Rublowsky, *Pop Art* (New York: Basic Books, 1965), 112. Rublowsky here recognized that Warhol's statement was not meant simply as a way to avoid giving answers: "His answer is, of course, part of the pose. The probe is deflected. Yet, it is not just a simple evasion. Warhol tells us, in effect, that a human being is a complex creature that is something more than the mere sum of his days."

[19] Alan Solomon, introduction, *Andy Warhol* (Boston: Institute of Contemporary Art, 1966), unpaged. For a discussion of the television show for which Solomon interviewed Warhol, see Caroline A. Jones, *Machine in the Studio: Constructing the Postwar American Artist* (Chicago: University of Chicago Press, 1996), 91-3.

[20] This practice is discussed in Erik Barnouw, *The Golden Web: A History of Broadcasting in the United States*, vol. 2 (New York: Oxford University Press, 1968), 104.

[21] See, for example, Ralph Flint, "Matisse Gives Interview on Eve of Sailing," *The Art News*, 3 January 1931, 3-4 (this is the first interview with an artist to appear in *The Art News*), and Laurie Eglington, "Marcel Duchamp, Back in America, Gives Interview," *The Art News*, 18 November 1933, 3 and 11.

[22] The interviews were done with Gene Swenson and appeared in the November 1963 and February 1964 issues of *ARTnews*. (Warhol's interview is in the November issue.)

[23] Malcolm Cowley, introduction to *Writers at Work: The Paris Review Interviews* (New York: Viking, 1959), 3-4.

[24] Alexander Eliot, foreword to Selden Rodman, *Conversations with Artists* (New York: Devin-Adair, 1957), viii.

[25] Daniel J. Boorstin, *The Image, or What Happened to the American Dream*, 25th anniversary edition, published as *The Image: A Guide to Pseudo-Events in America* (New York: Atheneum, 1987), 11.

[26] Warhol and Hackett, *POPism,* 130.

[27] Michael Pousner, "Andy, Baby! Watcha Up to these Days?" *Daily News*, 30 May 1972; and Emile de Antonio and Mitch Tuchman, *Painters Painting: A Candid History of the Modern Art Scene, 1940-1970* (New York: Abbeville Press, 1984), 29.

[28] I offer another perspective on how these activities fit into Warhol's artistic production overall in my book, *Andy Warhol, Poetry, and Gossip in the 1960s* (Chicago: University of Chicago Press, 1997), 53 and chapter 5. (The latter is reprinted in *Experimental Film, The Film Reader*, ed. Wheeler Winston Dixon and Gwendolyn Audrey Foster [New York: Routledge, 2002]).

[29] Colacello, *Holy Terror*, 250-51.

[30] *Andy Warhol* (Stockholm: Moderna Museet, 1968), unpaged.

[31] Several television programs remained fifteen minutes long up until 1963; see Erik Barnouw, *The Image Empire: A History of Broadcasting in the United States*, vol. 3 (New York: Oxford University Press, 1970), 208 and 246.

[32] See John Dunning, *Tune in Yesterday: The Ultimate Encyclopedia of Old-Time Radio 1925-1976* (Englewood Cliffs, N.J.: Prentice-Hall, 1976), 72 and 109, respectively.

[33] An example that is amusing to think about in our context is James R. Ryals, "Successful Interviewing," *FBI Law Enforcement Bulletin* 60 (March 1991): 6-7.

[34] Boorstin, 15.

[35] "Pop Art? Is It Art? A Revealing Interview," 19. One journalist even compared Warhol's interviewing approach to that of the politician: "Although he loves to be interviewed, Andy has a politician's polish and poise in delivering nonanswers" (Pousner, "Andy, Baby!").

[36] Of course, published interviews are edited and therefore do not record verbatim what Warhol said; yet we can be fairly sure that the pattern I have described here is an accurate characterization of Warhol's behavior in interviews, since it is evident in several of his interviews. One good example is a conversation he participated in along with two other artists and a moderator, that was broadcast on the radio in 1964 and published, in an edited form, two years later. Early on in

this conversation, when asked how he got involved with pop imagery, Warhol replied that he was too high to respond, and recommended that the moderator ask someone else a question. However, as the discussion progressed (and was not focused on him), he began to speak up, observing, for instance, when the topic turned to Lichtenstein's comic-strip paintings, that because of such art, comic strips now acknowledged their creators when previously they had not. See Bruce Glaser, "Oldenburg, Lichtenstein, Warhol: A Discussion," *Artforum* 4 (February 1966): 20-24.

[37] Bennard B. Perlman, "The Education of Andy Warhol," *The Andy Warhol Museum: The Inaugural Publication* (Pittsburgh: Andy Warhol Museum, 1994), 153.

[38] Glenn O'Brien, "Interview: Andy Warhol," *High Times*, 24 August 1977, 36.

[39] *Andy Warhol's Index (Book)* (New York: Random House, 1967), unpaged.

[40] "Warhol's Latest: The Silent Show," *New York Post*, 10 October 1967.

[41] Warhol spoke of Allen Midgette's performances as Warhol in *POPism*, 247-48.

[42] Jean-Pierre Lenoir, "Paris Impressed by Warhol Show," *New York Times*, 18 May 1965.

[43] Gretchen Berg, "Nothing to Lose: Interview with Andy Warhol," *Cahiers du cinema in English* 10 (May 1967): 42.

[44] Matthew Collings, "Andy Warhol," *Artscribe International* 59 (September-October 1986): 44.

[45] Lenoir, "Paris Impressed by Warhol Show."

[46] Walter Hopps, "An Interview with Jasper Johns," *Artforum* 3 (March 1965): 34.

[47] Paul Taylor, "Andy Warhol: The Last Interview," *Flash Art International* 133 (April 1987): 41.

[48] Peter Selz, "Pop Goes the Artist," *Partisan Review 30* (Summer 1963); reprinted as "The Flaccid Art" in *Pop Art: The Critical Dialogue*, ed. Carol Anne Mahsun (Ann Arbor: UMI Research Press, 1989), 80-81.

[49] John Ashbery, "Andy Warhol in Paris," *New York Herald Tribune* (International Edition), 17 May 1965; reprinted in Ashbery, *Reported Sightings: Art Chronicles 1957-1987*, ed. David Bergman (New York: Alfred A. Knopf, 1989), 121.

[50] G. E. [guest editors Clem Goldberger, Jan Lavasseur, and Joanna Romer], "Warhol," *Mademoiselle* 65 (August 1967): 325. For two examples of his subsequent repetition of this claim, see Neal Weaver, "The Warhol Phenomenon: Trying to Understand It," *After Dark* (January 1969): 30, and Gelmis, *The Film Director as Superstar*, 67.

[51] Andy Warhol, *The Philosophy of Andy Warhol (From A to B and Back Again)* (New York: Harcourt Brace Jovanovich, 1975), 180. In this passage, Warhol falsely claimed that earlier in his career he did not read the reviews of his work. In fact, he had collected reviews of his work all along, as well as interviews with him. Elsewhere in the *Philosophy* book, he suggested that he had stolen phrases from his scrapbook clippings for the purpose of crafting a description of himself (p. 10). On Warhol's idea of using these scrapbook clippings for the *Philosophy* book, see also Colacello, *Holy Terror*, 207-8. Warhol not only incorporated the words of his critics into his verbal creations, but also sometimes gave these words a visual form; see my essay, "The Word Transfigured as Image: Andy Warhol's Responses to Art Criticism," *Smart Museum of Art Bulletin* 7 (1995-96): 9-17.

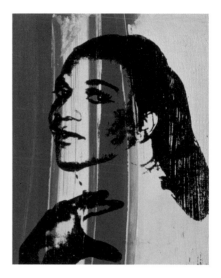

INTERVIEW

Artscribe
September-October 1986

Andy Warhol Interviewed by Matthew Collings

Your new book, *America*, is very patriotic.

That's just photo opportunity.

What does that mean?

I don't know. Everybody uses that phrase. It means just being in a photo or something. When somebody says, "It's a photo opportunity," you just stand there and they take your picture. It's actually just having your picture taken.

I mean the writing is very patriotic. You see things and they make you love America.

Well, I like every place. There are a lot of pictures of Paris in that book that were put in because they were good pictures, I don't think anyone will know the difference.

I thought it was very provocative to say that you loved America especially at this time. . .

Well, you don't have to think about it. It's so exciting in America you don't really have to think about it.

It would be very provocative to many Europeans because they're not loving America at present.

Really? I like France. They love it when we go over there. I was actually in Paris when the bombing of Libya was going on and it didn't seem to be such a big thing over there. I realized when I came back to New York that America has so much media — we have twenty-four hour news, you know, and that blows everything out of proportion. There are so many news stations — TV stations cable stations. Which is kind of great. One of my favorite stations in Paris is called "the clock," where they just tell you what time it is. I don't know if they still have it but a couple of years ago they did.

Was your book just compiled casually, taking photographs, jotting down notes . . .?

Yes, the pictures aren't really anything…I saw some great pictures yesterday. I went to the Seagram building and they had pictures by somebody called Wintergarden. He had every great moment — like the back of President Kennedy…they were great pictures.

How did you compile the writing in the book? Was it from casual notes?

It was just saying one thing and not meaning it; making things up. I've been meeting so many people now who say they're on health-food diets and then right in front of your eyes they're eating red meat, drinking wine…so it doesn't matter what anyone says.

You're having an exhibition in London soon, at the Anthony d'Offay gallery...
Yes, it's just one portrait. A self portrait. I guess it's PR for the gallery...

Who makes the paintings now?
Oh I do, I always made them myself.

I remember once you said that Brigid made them.
No, somebody else said that and I just agreed. She was just here, you should have asked her.

Do you have much contact with the artworld? Do you read the art magazines?
I read them when I travel. I like the ads.

You don't think there are debates and issues that you should keep up with?
Well, there's nothing right now. There are so many galleries though — every day there's a new gallery here. It just keeps going and it's kind of exciting. There are so many.

How do you decide on your subjects?
The dealers tell me what to do.

You don't really want to think about it . . .?
No. The dealers are becoming art directors. They tell you everything.

Do you think the dealers have a stronger position than critics?
I guess so.

The artists are the most passive?
Yes.

Perhaps it's different from one artist to another?
Yes, it is different.

You go to auctions at the weekends . . .
Auctions are the only place where you can actually touch everything. It's the best place to go and touch something.

What sort of things?
Every category. It's actually like going to college. If you go while the auction's taking place you get three minutes on each piece, each painting. You look at it and they talk about it. It's really great, it's like school. You see things you've never seen before.

There's a book just published by *Parkett* magazine with Kiefer, Beuys, Cucchi and Kounellis all discussing America and Europe and the role of the artist now. They say that America dominates the artworld and they resent that.

I don't think it's working that way now. For example, the Basel art fair — everybody goes there.

But art still seems to have to go through New York to be recognised. Or do you think that's just a myth?

I think it was never really true. You know, it's still French art that brings in all the money. And I just went into a gallery on Madison Avenue where Henry Moore sells like hot cakes — I mean, big million dollar sculptures. The gallery had just sold two big 1978 Henry Moore sculptures for a couple of million dollars.

It would be hard to sell them in England for that price. The critical consensus too seems to be set in New York. The critics here are very important —the big museum shows, the reception for art here…

No, there are bigger museum shows in Europe — in Germany, Amsterdam.

The Europeans all seem to express some kind of resentment about the American influence on art.

No they don't. I don't think so.

The artists in the *Parkett* discussion do. They think it's a problem that European artists have to come to terms with.

Well, I don't know if that's really to do with art. Joseph Beuys was such a great artist though…

He defends you.

He does?

Yes, in a discussion with Kounellis about American imperialism and whether you are an artist or a publicist . . .

Well, Beuys was such a great person. Paris never really bought American art but Germany certainly did. Everyone in Germany enjoys art more than they do in America. People there are educated to enjoy it more than they are here. People think there are so many collectors here but there aren't really. The few that there are get sort of well known because they do it in a big way but there's really not that many. I guess Saatchi — is he American?

He's English.

Well, look at him then. He's one of the biggest there is. There were people in Germany in the sixties who started up collections that were really good, and then Saatchi comes along on his own and he's even bigger. And then someone else will come along…But people are richer here and you'd think on the whole there would be more buyers for art — you know, they could do anything here, they could buy the biggest collection. But they don't like art as much. So that attitude you're talking about is all wrong. But I think they should present art in movie theatres or something. It shouldn't just be a case of carrying out a couple of pictures in a gallery…

Do you have any more books planned?

Yes, a "how to party" book. Do you have a good title for it?

"Guide to Parties."

I thought a long title would be funnier.

"A Thousand and One Parties."

That's pretty good. What else?

"Four Thousand Parties."

"Four Thousand Parties?" Maybe "One Million Parties?"

Nobody would count them…

Yes, that's a great idea.

And it would give the impression of abundance.

That's a very good idea — "One Billion Parties."

EXHIBITION CHECKLIST

Andy Warhol
Work and Play

Andy Warhol
Christmas Card with Dancing Figures, 1948
Tempera on folded paper
$10^3/_4$ x $20^5/_8$"
Collection Mark Ciufo, North Country Books

Andy Warhol
Head of a Woman, ca. 1953
Ink and colored pencil on paper
$6^7/_8$ x 6"
Collection Mark Ciufo, North Country Books

Andy Warhol
Head of a Woman, ca. 1953
Ink and tempera on paper
8 x 6"
Collection Mark Ciufo, North Country Books

Andy Warhol
Girl with Raised Arm (Bonjour), 1953
Offset lithograph on paper
12 x 9"
Lisanby Collection, courtesy Sands & Company Fine Art, New York

Andy Warhol
Andy Warhol: The Golden Slipper Show, 1956
Bodley Gallery exhibition announcement
Screenprint on paper
$6^1/_4$ x $21^5/_8$"
Collection Mark Ciufo, North Country Books

Andy Warhol
Kyoto, Japan, 1956
Offset lithograph and watercolor on paper
18 x $14^1/_2$"
Lisanby Collection, courtesy Sands & Company Fine Art, New York

Andy Warhol
In the Bottom of My Garden, ca. 1956-57
Ink and watercolor on paper
16 x 20"
Private collection

Andy Warhol
Portrait of a Young Man, ca. 1956
Ballpoint pen on paper
$16^3/_4$ x $13^7/_8$"
Private collection

Andy Warhol
Untitled (Foot with Crab), ca. 1957
Ballpoint pen on paper
17 x 14"
Private collection

Andy Warhol
Wild Raspberries, 1959
Bodley Gallery exhibition announcement
Hand-colored lithograph and rubber stamp on paper with interleaving tissue
9$\frac{1}{2}$ x 7"
Lisanby Collection, courtesy Sands & Company Fine Art, New York

Andy Warhol
Cosmetic and Cosmetic Accessories, 1962
Graphite, Dr. Martin's aniline dye, and collage on paper
29 x 23"
Private collection

Andy Warhol
Ethel Scull, 1963
Silkscreen ink on synthetic polymer paint on canvas
19$\frac{7}{8}$ x 15$\frac{5}{8}$"
Private collection

Andy Warhol
Ethel Scull, 1963
Silkscreen ink on synthetic polymer paint on canvas
19$\frac{7}{8}$ x 15$\frac{7}{8}$"
Private collection

Andy Warhol
Ethel Scull, 1963
Silkscreen ink on synthetic polymer paint on canvas
19$\frac{7}{8}$ x 15$\frac{7}{8}$"
Private collection

Andy Warhol
Jackie, 1964
Silkscreen ink on synthetic polymer paint on canvas
20 x 16"
Private collection

Andy Warhol
Birmingham Race Riot, 1964
From *Ten Works by Ten Painters* portfolio
Screenprint on paper
20 x 24"
Collection Robert Hull Fleming Museum, University of Vermont, Museum purchase

Andy Warhol
Ladies and Gentlemen, 1975
Silkscreen ink on synthetic
polymer paint on canvas
14 x 11"

Private collection

Andy Warhol
The American Man - Watson Powell, 1964
Silkscreen ink on synthetic polymer paint on canvas
16 x 16³/₄"
Private collection

Andy Warhol
The American Man - Watson Powell, 1964
Silkscreen ink on synthetic polymer paint on canvas
16 x 16³/₄"
Private collection

Andy Warhol
Campbell's Soup Can on Shopping Bag, 1964
Screenprint on paper shopping bag
23¹/₄ x 17"
Collection Robert Hull Fleming Museum, University of Vermont, gift of
 Kenward Elmslie in memoriam Joe Brainard

Andy Warhol
Marilyn, 1967
From *Marilyn* portfolio
Color screenprint on paper
36 x 36"
Whitney Museum of American Art, New York, purchase

Andy Warhol
Self-Portrait, 1967
Screenprint on paper
23¹/₁₆ x 23"
Whitney Museum of American Art, New York, purchase with funds from the
 Katherine Schmidt Shubert Purchase Fund

Andy Warhol
Campbell's Soup, 1968
From *Campbell's Soup I* portfolio
Screenprint on paper
35¹/₄ x 23¹/₄"
Collection Middlebury College Museum of Art, purchase with funds provided by the
 Friends of Art Acquisition Fund and a matching grant from the National
 Endowment for the Arts

Andy Warhol
Flowers, 1970
From *Flowers* portfolio
Screenprint on paper
36¹/₁₆ x 36"
Collection Williams College Museum of Art, gift of Tennyson and Fern Schad,
 Class of 1952

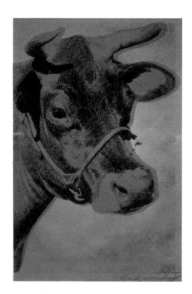

Andy Warhol
Cow, 1971
Screenprint on wallpaper
44 x 30"

Collection Robert Hull Fleming
Museum, University of Vermont,
gift of Mrs. Betty Stroh '31

©2003 Andy Warhol Foundation
for the Visual Arts / Artists
Rights Society (ARS), New York

Andy Warhol
Electric Chair, 1971
A portfolio of 10 screenprints on paper
35³/₈ x 47⁷/₈" (each)
Whitney Museum of American Art, New York, gift of Peter M. Brant

Andy Warhol
Cow, 1971
Screenprint on wallpaper
44 x 30"
Collection Robert Hull Fleming Museum, University of Vermont,
 gift of Mrs. Betty Stroh '31

Andy Warhol
Mick Jagger, 1975
Screenprint on paper
43¹/₂ x 29"
Collection Middlebury College Museum of Art, gift of Judy Carlough '72

Andy Warhol
Ladies and Gentlemen, 1975
Silkscreen ink on synthetic polymer paint on canvas
14 x 11"
Private collection

Andy Warhol
Ladies and Gentlemen, 1975
Silkscreen ink on synthetic polymer paint on canvas
14 x 11"
Private collection

Andy Warhol
Ladies and Gentlemen, 1975
Silkscreen ink on synthetic polymer paint on canvas
14 x 11"
Private collection

Andy Warhol
Ladies and Gentlemen, 1975
Silkscreen ink on synthetic polymer paint on canvas
14 x 11"
Private collection

Andy Warhol
Skull, ca. 1976
Graphite on paper
20¹/₂ x 28"
Private collection

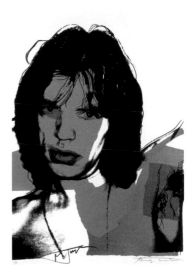

Andy Warhol
Mick Jagger, 1975
Screenprint on paper
43¹/₂ x 29"

Collection Middlebury College
Museum of Art, gift of Judy
Carlough '72

© 2003 Andy Warhol Foundation
for the Visual Arts / Artists Rights
Society (ARS), New York

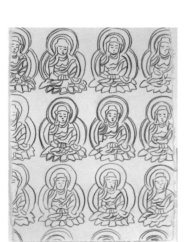

Andy Warhol
Buddhas, ca. 1983
Graphite on HMP paper
31³/₄ x 24"

Courtesy Andy Warhol
Foundation for the Visual Arts,
New York

©2003 Andy Warhol Foundation
for the Visual Arts / Artists Rights
Society (ARS), New York

Andy Warhol
Shadow, ca. 1978
Silkscreen ink on synthetic polymer paint on canvas
50 x 42"
Private collection

Andy Warhol
Untitled (Self-Portrait), ca. 1978
Polaroid SX-70 photograph
4¹/₂ x 3¹/₂"
The Polaroid Collections

Andy Warhol
Untitled (Self-Portrait), ca. 1978
Polaroid SX-70 photograph
4¹/₂ x 3¹/₂"
The Polaroid Collections

Andy Warhol
Untitled (Self-Portrait), 1979
Polaroid Polacolor photograph
20 x 24"
The Polaroid Collections

Andy Warhol
The Shadow, 1981
From *Myths* portfolio
Screenprint on paper with diamond dust
38 x 38"
Courtesy Ronald Feldman Fine Arts, New York

Andy Warhol
Gun, ca. 1981-82
Silkscreen ink on synthetic polymer paint on canvas
16 x 20"
Private collection

Andy Warhol
Crosses, ca. 1981-82
Graphite on paper
31⁷/₈ x 23³/₄"
Private collection

Andy Warhol
Crosses, 1982
Silkscreen ink on synthetic polymer paint on canvas
20 x 16"
Private collection

Andy Warhol
Buddhas, ca. 1983
Graphite on paper
31³/₄ x 24"
Courtesy Andy Warhol Foundation for the Visual Arts, New York

Andy Warhol
Madonna del Duca da Montefeltro, Piero dolla Francesca, 1984
From *Details of Renaissance Paintings* portfolio
Screenprint on paper
32 x 44"
Courtesy Ronald Feldman Fine Arts, New York

Andy Warhol
Rorschach, 1984
Synthetic polymer paint on canvas
20 x 16"
Collection Middlebury College Museum of Art, purchase with funds provided by the
 Electra Havemeyer Webb Memorial Fund

Andy Warhol
Map: Southern Africa, ca. 1984-85
Synthetic polymer paint on paper
31³/₈ x 23¹/₂"
Private collection

Collaborations and work by others:

Corkie (Ralph T. Ward) and Andy (Warhol)
Love is a Pink Cake, 1953
Offset lithograph on paper, 25 unbound pages
11 x 8¹/₂" (each)
Collection Mark Ciufo, North Country Books

Julia Warhola
Holy Cats by Andy Warhol's Mother
Offset lithograph on paper
9¹/₈ x 5⁷/₈"
Collection Gerard Malanga

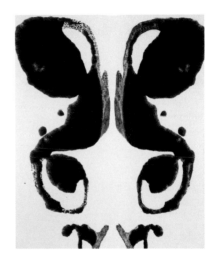

Andy Warhol
Rorschach, 1984
Synthetic polymer paint on canvas
20 x 16"

Collection Middlebury College
Museum of Art, purchased with
funds provided by the Electra
havemeyer Webb Memorial Fund

Charles Lisanby
Andy Warhol during his Trip around the World, 1956
Photograph
8¹/2 x 11"

Lisanby Collection, courtesy Sands & Company Fine Art, New York

©2003 Sands & Company Inc., New York

Charles Lisanby
Andy Warhol during his Trip around the World, 1956
Photograph
8¹/2 x 11"
Lisanby Collection, courtesy Sands & Company Fine Art, New York

Amy Vanderbilt
Amy Vanderbilt's Complete Cookbook, 1961
with drawings by Andrew Warhol
Doubleday & Company, Inc.
Garden City, New York
Private collection

Edward Wallowitch
Gerard Malanga, First Day on the Job with Andy Warhol, 1963
Photograph
8 x 10"
Collection Gerard Malanga.

Gerard Malanga
Photomaton Assemblage (With Love from Andy Pie . . .), 1963
Photograph
20 x 16"
Collection and © Gerard Malanga

John D. Schiff
Andy Warhol in the Livingroom of his Townhouse, 1342 Lexington Avenue, NY, 1963
Photograph
10 x 8"
Collection Gerard Malanga

Gerard Malanga
Andy Warhol Photomaton Portraits, ca. 1964
Photograph
16 x 20"
Collection and © Gerard Malanga

Lorenz Gude
Andy Warhol and Gerard Malanga Silkscreening a Painting at the Factory, ca. 1964
Photograph
10 x 8"
Collection Gerard Malanga

Andy Warhol
Flowers, 1964
Leo Castelli Gallery exhibition announcement
Offset lithograph on paper
5¹/2 x 11"
Collection Gerard Malanga

Gerard Malanga
Flyer for Malanga poetry reading at Leo Castelli Gallery, 1964
Photocopy
10 x 8"
Collection Gerard Malanga

Andy Warhol and Gerard Malanga
Poem-Visuals, 1964-65
Laser-print facsimiles of originals (thermofax, ballpoint pen, typewriter and ink on paper)
Originals in private collection © Gerard Malanga
 Day Thoughts
 Untitled (The Electric Chair in a Room Made Silent by Signs)
 From Fresh Death (The Blazing Headache Seemed Pale among the Weeds)

Gerard Malanga
Andy Warhol: Portraits of the Artist as a Young Man, 1964-65
A film by Gerard Malanga
Photograph
20 x 16"
Collection and © Gerard Malanga

Andy Warhol
Poster for the 1965 Morris International exhibition, Toronto
Offset lithograph on paper
25 x 27⁷/₈"
Collection Robert Hull Fleming Museum, University of Vermont, Museum purchase

Anonymous
Andy Warhol and Edie Sedgwick at The Scene, 1965
Photograph
10 x 8"
Collection Gerard Malanga

John Rublowsky
Pop Art, 1965
New York: Basic Books
Collection Gerard Malanga

Gerard Malanga
Andy Warhol with the Velvet Underground and Nico, 1966
Photograph
16 x 20"
Collection and © Gerard Malanga

Wes Wilson
Pop - Op Rock, 1966
Offset lithograph on paper
19⁷/₈ x 13⁷/₈"
Collection Robert Hull Fleming Museum, University of Vermont,
 gift of Dr. Stephen and Trudi Cohen

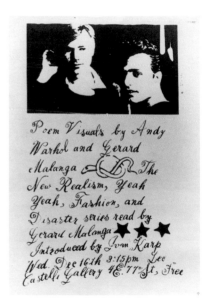

Gerard Malanga
Flyer for Malanga poetry reading at Leo Castelli Gallery, 1964
Photocopy
10 x 8"

Collection and © Gerard Malanga

Andy Warhol
Aspen 1, 1966
"Fab issue" designed by Warhol
12 x 9$^{1}/_{8}$"
Collection Gerard Malanga

John Palmer
Andy Warhol during a Break from Appearing in Piero Heliczer's Movie, "Joan of Arc," 1966
Photograph
10 x 8"
Collection and © Gerard Malanga

Gerard Malanga
Edie Sedgwick Photomaton Portrait, 1966
Photograph
20 x 16"
Collection and © Gerard Malanga

Andy Warhol
The Velvet Underground and Nico, 1967
Album cover designed by Warhol
Private collection

Gregg Barrios, editor (Vol. 1, No. 1)
Harbinger #1, July 1967
Collection Gerard Malanga

Andy Warhol and Gerard Malanga
Screen Tests / A Diary, 1967
New York: Kulchur Press
Collection Gerard Malanga

Andy Warhol
Andy Warhol's Index (Book), 1967
New York: Random House
Collection Gerard Malanga

Gerard Malanga
Group Portrait at the Warhol Factory, 1968
Photograph
10 x 8"
Collection and © Gerard Malanga

Andy Warhol
Interview, issues #1 and #2, 1969
Collection Gerard Malanga

Andy Warhol: The Early Works, 1947-59
Poster for the 1971 Gotham Book Mart exhibition
Offset lithograph on paper
16 x 12¹/₄"
Courtesy Sands & Company Fine Art, New York

Gerard Malanga
Chic Death, 1971
Cambridge, Mass.: Pym-Randall
Collection Gerard Malanga

Gerard Malanga
Taylor Mead, 1971
Photograph
20 x 16"
Collection and © Gerard Malanga

Gerard Malanga
Lou Reed, 1973
Photograph
20 x 16"
Collection and © Gerard Malanga

Andy Warhol and Bob Colacello
Andy Warhol's Exposures, 1979
New York: Grosset & Dunlap
Collection Gerard Malanga

Christopher Makos
Andy at "Hotel Baur au Lac," Zurich, 1981
Photograph
16 x 20"
Collection and © Christopher Makos
www.christophermakos.com

Christopher Makos
Andy Warhol In Drag, 1982
From *Altered Image* series
Photograph
20 x 16"
Collection and © Christopher Makos

Christopher Makos
Andy Warhol In Drag, 1982
From *Altered Image* series
Photograph
20 x 16"
Collection and © Christopher Makos

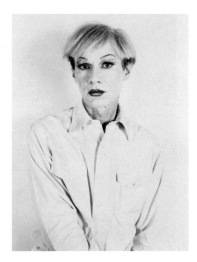

Christopher Makos
Andy Warhol In Drag, 1982
From *Altered Image* series
Photograph
20 x 16"

Collection and © Christopher
Makos

Christopher Makos
Andy Warhol In Drag, 1982
From *Altered Image* series
Photograph
20 x 16"
Collection and © Christopher Makos

Warhol & Basquiat Paintings
Poster for the 1985 Shafrazi Gallery exhibition
Offset lithograph on paper
19 x 12"
Courtesy Sands & Company Fine Art, New York

Andy Warhol
America, 1985
New York: Harper & Row
Private collection

New York *Daily News*, Feb. 23, 1987
Private collection

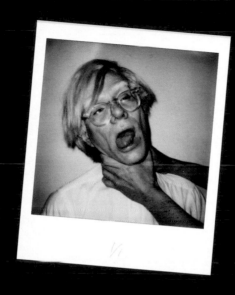

Andy Warhol
Untitled (self-portrait), ca. 1978
Polaroid SX-70 photograph
4¹/₂ x 3¹/₂"

The Polaroid Collections